PACIFIC PARK

D0398763

1

2/06

①

Norman Rockwell

BY COLLIER SCHORR

THE WONDERLAND
PRESS

Harry N. Abrams, Inc., Publishers

THE WONDERLAND PRESS

The Essential™ is a trademark
of The Wonderland Press, New York
The Essential™ series has been created by The Wonderland Press

Series Producer: John Campbell
Series Editor: Julia Moore
Project Manager: Adrienne Moucheraud
Series Design: The Wonderland Press

Library of Congress Catalog Card Number: 98-074608
ISBN 0-8362-1932-5 (Andrews McMeel)
ISBN 0-8109-5824-4 (Harry N. Abrams, Inc.)

Distributed by Andrews McMeel Publishing
Kansas City, Missouri 64111-7701

Unless caption notes otherwise, works are oil on canvas

Printed in Hong Kong

Harry N. Abrams, Inc.
100 Fifth Avenue
New York, NY 10011
www.abramsbooks.com

Contents

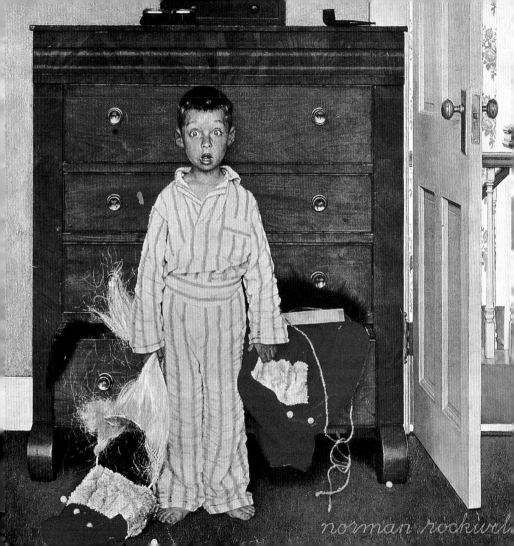

norman rockwell

It's Norman Rockwell!

He's everywhere. Walk into almost any store, with the exception, say, of a video rental shop or your corner deli, and you'll find a Norman Rockwell reproduction that coincides with that particular enterprise—plates and posters, t-shirts and coffee mugs, tote bags and coffee-table books. If you're lucky, you may even find an old issue of *The Saturday Evening Post*, whose covers Rockwell illustrated for more than four decades. In fact, used book and magazine dealers will be happy to relieve you of these issues. On a typical day, try purchasing a Rockwell-illustrated copy of the *Post* from a second-hand 'zine dealer in New York City and you'll hear, "Sorry, don't have any. Wish we did."

A Rockwell ad done for Massachusetts Mutual Insurance (Facts of Life) was borrowed by an AIDS activist group in 1987 to promote safe-sex awareness. Would Rockwell approve? His son, Tom Rockwell, says, "One of the things my father was associated with was tolerance. So I think it's fairly easy to know what he would have said." Bingo! Rockwell, the equal-rights advocate. Rockwell, the man-of-all-seasons illustrator. Rockwell, **the great American success story,** a self-made individual sharing his vision of America with the world and with generations to come.

OPPOSITE
The Discovery
1956

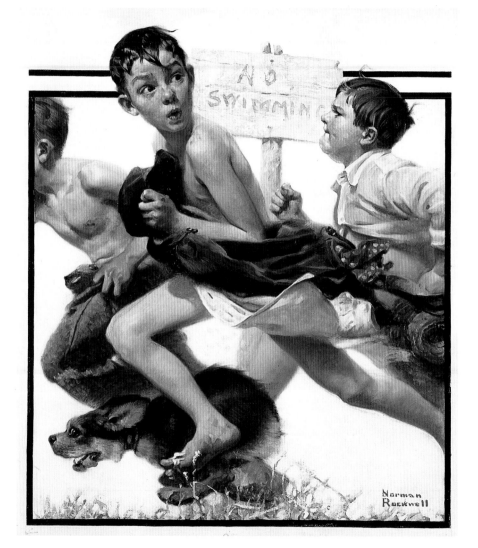

With His Finger on the Pulse...

In this book, we'll enter Rockwell's world and see amazing shifts in hairstyles and clothing, in design innovations and in sexual stereotypes, in America's stunning racism and our revulsion over past wrongs done to people of color. Norman Rockwell was not only in tune with the times, he was far ahead of them. In **the debate over whether Rockwell was a "true" artist or a "mere" illustrator** (ahem! some of the world's greatest art has come from illustrators), the more important discussion ought to focus on Rockwell as a conduit for expressing our individual right to freedom and happiness. *That's the skinny on Rockwell's greatness.*

But How did he do it?

More than any other popular artist of his time, **Rockwell took a stand**—and a public one, at that—against prejudice, bigotry, inequality, and against the stereotypes that keep us from living the lives we desire and that bully us into being people we are not. But he did not take this stand at the beginning of his life. He grew into this boldness after years of emerging, like the rest of us, from youthful innocence into empathy based on life experience. Even though Rockwell spent his early years painting mild-mannered, amiable scenes, he had no fear, later in his career, of attaching his name to more controversial subjects when the truth was less than rosy. In short, *he grew as an artist and as a human being.* Sure, he painted schoolgirls and dentists and grandmas

OPPOSITE
No Swimming
1921

7

and athletes. But he also evoked the America of the 1920s as it roared into the Great Depression—a country of poverty and frustration, of hopes gone sour and dreams destroyed by war, of families who clung together through good times and bad because family was all they had. Then he went on to paint heart-breaking scenes of racial prejudice.

A Country in Flux

Rockwell changed as America changed, and the legacy of his extraordinary talent is that we now have a panoramic view of the behaviors and concerns that characterized the lives of many Americans throughout the 20th century. It's all there—the quaint little prom dances alongside the chilling resistance to desegregation—the comedy and drama, conflict and harmony, ambition and despair. Here is Rockwell in full color for you to puzzle over and enjoy—a **pop-culture icon** who expresses America's spirit and preoccupations, for better or for worse. Though critics have often called it corny, Rockwell's art resonates with the masses. At the same time, it leads us to wonder *what's going on beneath the cheery surface* of all those smiling children and cute little puppy dogs.

How About *You?*

When someone mentions Rockwell, what do *you* think of? Maybe Thanksgiving, even if the holiday as celebrated in your home doesn't resemble the one painted by Rockwell, with its different generations of

animated, **Ivory-soap-scrubbed relatives** gathered around a table decked out with the family's best glassware and china, with steaming bowls and platters of traditional holiday fare. In Rockwell, light pours in, warm and comforting. The air is steamy and fragrant with the smells of roast-turkey skin, sagey stuffing, and spices. **Voices are happy,** the china clatters, and there's bursts of laughter.

OPPOSITE
Freedom From Want, 1943

Does your Thanksgiving table look different? Perhaps. But the underlying mood is probably closer than you think to the one captured by Rockwell. The magic and legacy of this much-loved artist is that *he painted what we want to remember* about ourselves, our childhoods, our families, and about American life and values in the 20th century—or what we *wish* our lives had been like when we were growing up.

The Big Cahuna of Illustration...and More!

Norman Rockwell (1894–1978) is **an American institution.** We're familiar with his work because we've seen it so often. His images of home and hearth, family and patriots, small-town life and outings to the country are so "knowable" and so likeable that we feel comfortable and utterly enchanted with them. Regardless of what the critics say, his art resists simplistic and superficial classification.

Even though Rockwell was a well-known public figure, **he was a private man** and is not easily pigeonholed. You think you know about this American one-of-a-kind, right? So try this little quiz.

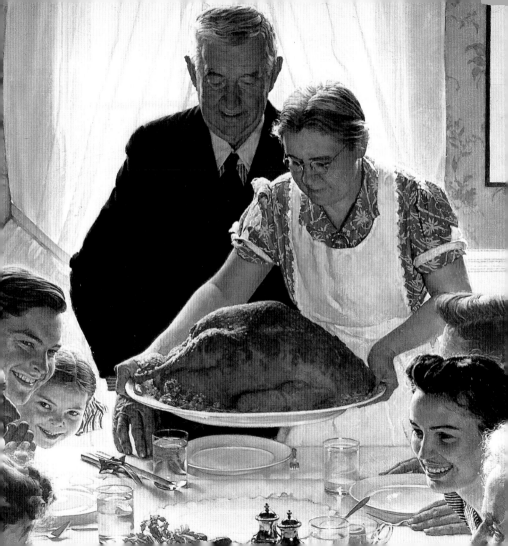

Which of the following are **TRUE or FALSE?**

Norman Rockwell:

- admired the drip paintings of Jackson Pollock
- made several trips to Paris, seeking the inspiration of Modern art
- was a genuinely nice, unpretentious man
- dropped out of high school
- hobnobbed with the rich and famous
- was born and bred in New York City
- painted works collected by Steven Spielberg and Ross Perot
- suffered from depression

The answers? All eight are true, even if his reason for dropping out of high school was to enroll in art school, and even if some of his childhood was lived in the suburbs north of Manhattan.

Pardonnez-moi, Art World!

You've probably had the perplexing experience of standing next to someone in a museum who carries on as if he/she's an art expert, right? "This is Picasso's Blue Period," they'll say, when looking at *Ma Jolie,* a Cubist painting made after the end of his Blue Period. Well guess

what? Sometimes "important" art critics at major news-papers carry on this way, too. With Rockwell, the big debate has always been: **Was he an "artist" or an "illustrator?"** The traditional distinction has been that illustrators are hired to skillfully execute *other people's* visions (such as an author's story line or an advertiser's creative campaign), whereas the artist expresses his/her own talent and executes works that are true only to the artist's own inner need to create.

While Rockwell did indeed think of himself as an illus-trator—and called himself that in his 1960 bestselling memoir, *My Adventures as an Illustrator*—that's not what the *real* debate is about here. Instead, you'll find art critics who blow him off as an irrelevant hack-for-hire who painted what his magazine editors told him to paint and had no particular vision or creative force that uplifted and inspired viewers. *Huh???*

Three Ladies Gossiping, 1929

Critics seem to forget that Rockwell's creations have delighted millions of people, year after year, both during his lifetime and long after his death in 1978. So it comes back to the tired argument that critics think they know better than the public—that a critic's eye is more discerning than a factory worker's heart. Rockwell's

critics maintain that he endlessly repeated the same old tired images of "All is well in the world," a kind of flawless, perfect family unit in which order, authority, and correct behavior rule the day. While there is some truth to this, Rockwell amounts to much, much more, as you will see.

Great Art vs. New Art

From about 1980 onward, it has not been cool for "true" art lovers to show enthusiasm for Norman Rockwell. His reputation as an artist has been battered in a kind of **high-art vs. low-art war** that began in the late 1940s and early 1950s, when Rockwell was at the height of his popularity and when art-world critics were thrilled with the work of Modern artists—in particular, those who were experimenting with the innovative new **Abstract Expressionism** (also called AbEx, or The New York School). The major AbEx painters were **Jackson Pollock** (1912–1956), **Robert Motherwell** (1915–1951), **Willem de Kooning** (1904–1997), and **Franz Kline** (1910–1962). While the latter were dripping and pouring and squooshing paint onto their canvases, Rockwell was capturing the America of his time, a world of changing social customs and emerging technologies and increasingly complex family relationships, set against a backdrop of a massive move from rural America to the big cities and industrialized milieux. If the Modern painters distorted the human figure beyond recognition, Rockwell profiled it in all its humanity. His admirers felt warm and

safe when they viewed his art. His work had an emotional impact on them and instantly brought smiles to their faces.

Before Abstract Expressionism, American art was essentially pictorial. Subject matter was recognizable and often told a story by expressing realistic details. When the Abstract Expressionists came along, critics praised them for creating the *first original movement of American art*—which critics also considered the only truly modern body of work produced in America. In doing so, they hexed Norman Rockwell, relegating him to the Land of Corn (as in *corny*) and to the Netherworld of Commerce. Their enchantment with the New was like putting on blinders: As the century progressed, they looked straight ahead, always applauding the "next new thing," yet not always seeing the forks in the road and the parallel paths. Norman Rockwell was on a parallel path and made extraordinary works that rival some of the best of the AbEx artists. Yet he was considered an irrelevant holdover from some remote past. That's why, ever since the 1950s, the art world has had a kind of stony silence about him. With a roll of the eyes and a "knowing" glance to each other, art experts and academics banish him to the ranks of low-end nostalgia.

Never Fear, Rockwell is Here!

Well watch out, art world, 'cause **Norman Rockwell is back**—and he's proving to be an artist of considerable longevity and impact. Scenes

from his paintings are re-enacted in such Stephen Spielberg movies as *Saving Private Ryan,* and his style continues to tap a rich and responsive chord in millions of viewers. If Rockwell were not beloved by a vast public, we would not see his images on products at Bed, Bath & Beyond or in the in-flight magazine of American Airlines.

How do *you* feel about Rockwell? Perhaps you bristle at the art-world's condescension (*"he occupies no place in art history"*) and will savor your stroll through this book, enjoying the images and smiling at the world captured in them. But maybe you'll agree with the critics that this artist is "merely" an illustrator.

Whichever path you choose, **go with your gut when you look at Rockwell's art.** Forget about the shoulds and shouldn'ts. See whether you feel happier, wiser, or emotionally uplifted by it. Does it make you smile or feel sad? Ask yourself why you like or dislike it, whether you consider Rockwell a creative talent or merely a skilled craftsman. Is his work the result of inspiration or instruction? See if he changes the way you view the world or causes you to ask questions you hadn't thought of before. And remember: While Rockwell is a great springboard for the debate on art vs. craft, the secret behind his longevity is that *his paintings are emotionally honest* and radiate the kind of love and connectedness among people that we all long for.

Sound Byte:

"We have a new-born Rockwell who can no longer be looked at with sneering condescension and might well become an indispensable part of art history."

—ROBERT ROSENBLUM, art historian,
Artforum/Bookforum, Summer 1998

In the final years of his life, Rockwell seemed to have slipped quietly out of the "liberated" lives of Americans. The Vietnam War shattered America's national confidence and Woodstock tossed old values into the mud. Although Rockwell was then painting socially conscious themes with sublime sensitivity, his career and his art were more or less dismissed for the last 15 years of his life.

But he is back and you'll soon see why. There is much to love here and, significantly, a lot more than meets the eye. For starters, Rockwell is:

- A superb draftsman and a consummately skilled painter

- An artist with a flawless sense of composition and color, whose designs use the allotted spaces with the aesthetic authority of a master

- A man with a visceral understanding of human mortality and the changing nature of all experience

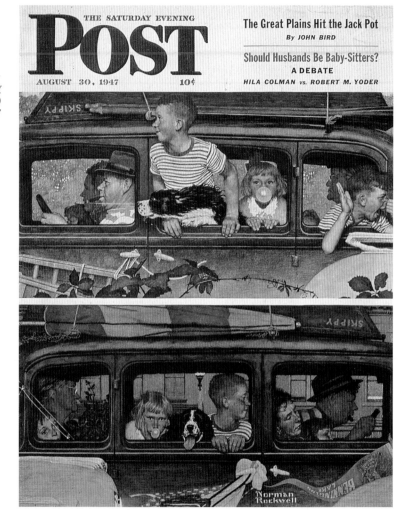

Going and Coming
(aka *The Outing*)
1947

The next time a Rockwell painting comes up for auction at Sotheby's or Christie's, watch what happens when the bidding starts. The very critics who poo-poo Rockwell will gasp at the prices.

Not a Picturesque Family

And so the story begins: Norman Rockwell comes into the world on **February 3, 1894** in a back bedroom of a brownstone on 103rd Street near Amsterdam Avenue in New York City. The Upper West Side neighborhood at this time is on the northern fringe of respectability, but it's what the Rockwells can afford. His family is not exactly the image of the family he will later portray in his paintings. Norman's father, **Jarvis Waring Rockwell** (known as Waring, or Potty), is the office manager of a textile firm where he started his career as an office boy. The handsome Waring has fussy habits and an aura of gentility, apparently passed down from his upper-middle-class family of successful New York City coal dealers and rug manufacturers. This upbringing also seems to have contributed to an **aloofness** that keeps his two boys at arm's length.

Norman's mother, **Nancy "Baba" Hill,** is one of 12 children from a family that came to America shortly after the Civil War. Her father, a mediocre artist, was a hard-drinking, down-on-his-luck painter of pet portraits and of sentimental over-the-sofa paintings (called "pot-boilers"). For these paintings, he relied on his children to assist in

painting the water, trees, moon, and stars. In this quaint little assembly line, Hill would paint the central subject and pass the canvas on to the kids, who would each paint a portion of it. According to Rockwell, Grandfather Hill "painted in great detail—every hair on the dog was carefully drawn, the tiny highlights in the pig's eyes could be clearly seen."

OPPOSITE
Easter Morning
1959

Little is known about Baba beyond the fact that she and Potty are religious, that she often retreats for long periods of time to her darkened bedroom with wet cloths on her forehead, and that she takes great pride in her English ancestry. She discourages Norman from following in his grandfather's footsteps, lest they lead him to failure and alcoholism. Baba's **mélange of mysterious illnesses** stunt the Rockwells' family life. There is evidence that she suffers from clinical depression, and, if true, this might explain the "disappearances" that force the whole family to live in boarding houses in New York City and Westchester County for extended periods of time, due to her inability to care for the family.

> *FYI:* **Religion**—The Rockwells were a religious family and the boys were sent to sing in church choirs. Normally choirboys were paid a small fee, but the ever-pleasant Mrs. Rockwell wouldn't hear of it. Later, Rockwell's work referred to the Bible and was often associated with a "good Christian" ethic; but as an adult, he did not go to church. It did not interest him, as we can see from the expression on the father's face in *Easter Morning*.

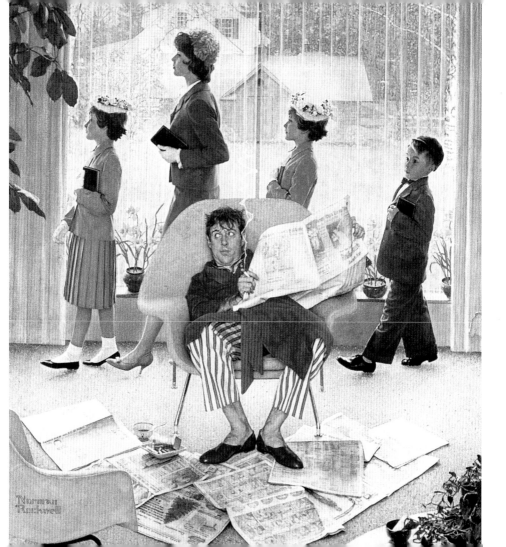

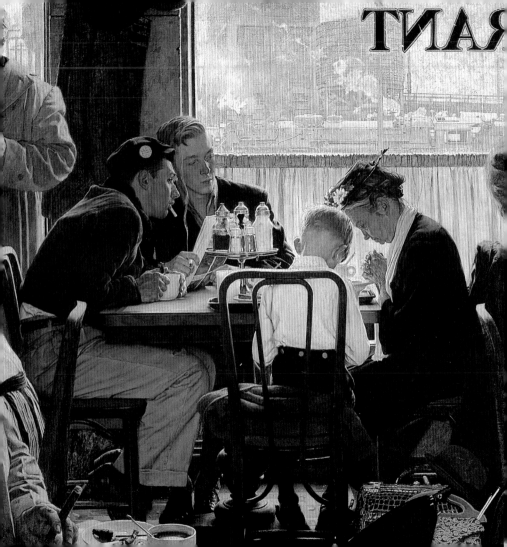

The Worst of Times is the Best to Draw

Since the Rockwells own two phonograph records by the great tenor Enrico Caruso, they acquire a reputation in the neighborhood as being "cultured folk." Waring sketches—actually, he copies—paintings and drawings from magazines of the day. Most evenings, after the dishes are cleared from the dining-room table, he reads to Norman and his older brother, **Jarvis,** from the picturesque novels of **Charles Dickens** (1812–1870). Norman sketches the Dickensian characters as he imagines them, and later recalls having intense feelings for "the variety, sadness, horror, happiness, treachery, and twists and turns of life: the sharp impressions of dirt, food, inns, horses, streets." It is often pointed out that Rockwell paints with oils the way Dickens paints with words. Dickens implanted in the artist a desire to record every number on a watch dial, every pore in a nose, and every dot in a polka-dot blouse.

> **FYI: Family notoriety**—Rockwell's full name, Norman Percevel Rockwell, was the choice of his Anglophile mother. (Jarvis was named after his father.) Baba claimed unbroken descent from one Norman Percevel, who is said to have kicked revolutionist Guy Fawkes down the stairs of the Tower of London in 1605 while Fawkes was jailed for plotting to blow up the Houses of Parliament. "Remember, Norman Percevel," the artist later recalled his mother exhorting, "it's spelled with an *e; i* and *a* are common."

OPPOSITE
*Thanksgiving
(Saying Grace)*
1951

City vs. Country

Norman spends his first nine years in New York City, loathing the grimy streets and dingy buildings and trash-strewn vacant lots of his neighborhood. When we think of Rockwell and youth, it's usually Boy Scouts that come to mind. **Yet he did not have the picturesque boyhood** he so poignantly describes later in his work. The young Rockwell was pigeon-toed, wore corrective shoes, had narrow shoulders and a frail, skinny neck, and today would've been considered a classic nerd. It is not surprising that his first *Saturday Evening Post* cover features two boys teasing a third, who is dressed in a suit and is pushing a wicker baby carriage. The fear of being tagged and shamed as a sissy is the overriding concern in this picture, and it is the story of Norman Rockwell's early years.

One **early memory of seeing a drunken woman savagely beat a man** with an umbrella forever changes his feelings about the city. Recalling these unhappy New York moments years later, he mentions the unpleasant details of life as he lived it, such as seeing "a scrap of newspaper rolling slowly across patches of dirty snow." The dreariness of

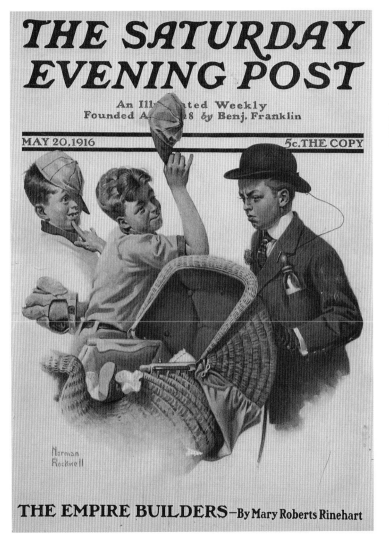

Boy Pushing
Baby Carriage
(aka *Salutation*)
1916

the streetscape evolves into **a profound distaste for life in large cities.**

You can take the boy out of the city *and* you can take the city out of the boy. Looking at Rockwell's down-home subject matter, it's almost incomprehensible that he lived in large cities for most of his childhood and a good part of his adulthood. What accounts for his exquisite affinity for country kids and small-town families seems to be the string of **happy summers boarding with farm families in upstate New York,** fueled by a rich imagination for idealizing life as it might be.

Sound Byte:
"I guess I have a bad case of the American nostalgia for the clean, simple country life as opposed to the complicated world of a city....I would not have dwelt so long upon these summers I spent in the country as a child, except that I think they had a lot to do with what I painted later on.... The view of life I communicate in my pictures excludes the sordid and ugly. I paint life as I would like it to be."

—Norman Rockwell

Besides soaking up the smells of hay and grass and sun-roasted barn siding, the best parts of Rockwell's personality emerge when he gets to the country. **He loves the open and expressive faces of country people,** faces that "fit better into my kind of picture than city people['s]." At the end of the summers, he comes back to the city with frogs

and turtles he's caught—and when, inevitably, a couple of months later he finds them floating dead in the fishbowl, he grieves for the death of that summer.

At age 9, to Norman's great pleasure, the family moves to the town of Mamaroneck, in Westchester County, north of Manhattan. Suddenly the crowded streets and dark alleys of the big city are replaced by green grass and trees. These opened-up vistas will be the backdrops in his early paintings of young boys' lives.

A Nerd before it was Fashionable

Norman is the typical second son who grows up watching his older brother become the best athlete in school. While Jarvis is a "boy's boy," Norman sees himself a "a lump, a long skinny nothing, a bean pole without the beans." The word *lump* may refer to the prominent Adam's apple in his skinny neck. He sings in church choirs—St. Luke's and then the Cathedral of St. John the Divine—and lives in dread of being called Percy. On the street, he pulls a sleeve down over one hand to garner sympathy or he feigns a limp so that people will feel sorry for him.

But while Jarvis can win any sports tournament he enters, Norman can draw on command and does so, much to the

The Holdout, 1959

joy of his peers, who shout out different subjects at will. In 1908, at 14, **Rockwell decides to become an illustrator.** He makes the two-hour trolley and subway trip to New York City twice a week to take classes at the [William Merritt] **Chase School of Fine and Applied Art.** A year later, as a high school sophomore, he drops out at mid-year and enrolls at the **National Academy School,** where he engages in copying plaster casts. The fact that the school is free comes as an enticement to the impoverished art student, whose menial teenage odd jobs do not yield enough to pay for tuition anywhere.

After a strenuous program of drawing from plaster casts eight hours a day, six days a week, he switches to the **Art Students League of New York,** co-founded by Norman's hero, the great American book illustrator **Howard Pyle** (1853–1911), known for his lush, historically accurate portraits of damsels and pirates. There, Rockwell's destiny is sealed: He is now convinced that he made the correct choice in becoming an illustrator.

Howard Pyle at his easel, 1898

Happy at last, Norman studies anatomy with **Charles Bridgeman** (1864–1943) and illustration with **Thomas Fogarty** (1873–1938), who imparts his vision that illustrators must capture "an author's words in paint." (Fogarty encourages Rockwell to "step over the frame, Norman, over the frame and live in the picture.") He teaches devotion to detail and authentic rendering of detail. If a story describes a character riding the train to Poughkeepsie, Fogarty insists that the illustrator

actually ride the train and paint a view from the train window exactly as it is exists.

By the time Rockwell leaves the League, he understands that his job as an illustrator is to convey as much information as possible and to highlight the nuances that will either draw a reader further into a story or will itself become a complete tale. Instinctively, he feels an allegiance to the "consumer" of his work, the reader of the book or magazine.

The Hot Illustrators: Pyle and Gibson

The Art Students League, still on West 57th Street in New York City, is acknowledged to have been a true pioneer in training illustrators. As early as the 1880s, the school recognized the career opportunities presented by the strong growth of illustrated weeklies and monthlies and by the advertising revenues that fueled these publications. Howard Pyle's skills and his fire-the-imagination style of childrens' book illustration—especially of stories rich in history or legend—did as much as anything to advance the reputation of illustrators.

The other popular League-trained illustrator was the well-born **Charles Dana Gibson** (1867–1944), a master of black-and-white drawing best known for his Gibson Girls. The GGs were archetypal Anglo-Saxon exemplars of American womanhood: confident, flirtatious, elegant, and beautiful. They often appeared bare-shouldered and wearing wide black velvet choker bands around their womanly necks.

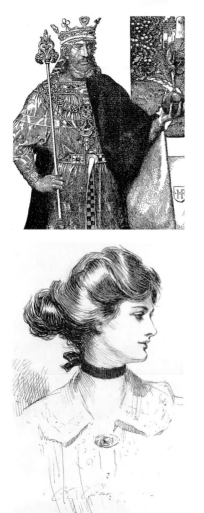

RIGHT
Howard Pyle
King Arthur, n.d.

FAR RIGHT
Arthur Rackham
Tom Thumb,
from *Grimm's
Fairy Tales*

BELOW LEFT
Charles Dana
Gibson
*A Daughter of
the South*

BELOW RIGHT
Frederic S.
Remington
*The Seventh
Cavalry,* 1894

Gibson eventually abandoned his frustrated aspiration to be regarded as a fine artist and instead worked toward raising the artistic reputation of illustrators, including his own, of course.

FYI: **Rockwell's part-time jobs**—Like most impoverished students, Rockwell found odd jobs to keep himself afloat. Among others, he appeared as an extra in productions at the Metropolitan Opera; he carried the paints of actress Ethel Barrymore, an amateur painter; and he worked a mail route.

Pyle, the "historian with a brush," is the artist Rockwell studies most and idolizes as a student. But he also admires the work of illustrator **J. C. (Joe) Leyendecker** (1874–1951), painter and sculptor **Frederic Remington** (1861–1909), American ex-patriot artists **James Abbott McNeill Whistler** (1834–1903), **John Singer Sargent** (1856–1925), the English-born **Arthur Rackham** (1867–1939), and the many Flemish and Dutch painters of the 15th through mid-17th century whose acute attention to the smallest detail never overrode their sense of composition.

The precocious Rockwell comes on the scene when Pyle is near the end of his life and Gibson is at the peak of his popularity. By the time Rockwell is fully launched in the early 1920s, the mass-market publishers and advertisers hold the power to make or break the careers of individual artist-illustrators.

THE HEYDAY OF AMERICAN ILLUSTRATION

The Golden Age of American Illustration began in the 1880s and ended about 1930. Before 1900, illustrators thought of themselves as peers of autonomous fine artists. The question of who paid—patronage—had not been forced by fine-art loyalists. But around the turn of the century, illustrators began to lose stature. What caused the change? The money, of course! The explosive growth of mass-market publishing, especially of weekly and monthly magazines, and of space advertising in those magazines created a huge need for accessible art that helped sell magazines by illustrating stories and by tempting the fast-growing consumer class to buy what- ever was pictured in the advertisements. Then, as now, ad revenues supported magazines. Magazines paid their best illustrators very well, and the common perception was that illustrators had struck a Faustian bargain: They traded in their integrity and independence in exchange for fees paid by greedy commercial businesses. To illustrate for *advertisers* was to invite scorn from noncommercial artists. By the end of World War I, most illustrators recognized that their art would never achieve the status of fine art, though many of them—including Rockwell—longed to be taken seriously and suffered a sort of jilted-lover syndrome.

ILLUSTRATION AND ADVERTISING

The rise of mass-market illustrated print media—and most especially of general-interest maga- zines targeted at women readers—can be attributed to the growth of an educated middle class in the late 19th century. In the first ten years of Rockwell's life, such magazines as *The Saturday Evening Post, Collier's, Ladies' Home Journal, Life,* and *Cosmopolitan* appeared and developed loyal audiences. Advertising agencies had come into being in the 1860s, although newspaper and poster advertising can be traced back to the beginning of the 19th century. But it wasn't until the late 1870s that ad agencies did much more than act as brokers between advertiser and publisher. As the national economy shifted from a primary base (producing what was needed to feed, shelter, and clothe Americans) to one based on consumerism, magazine publishing and the advertising industry became interdependent: Advertising revenues supported the publishers, and publishers offered a perfect vehicle to promote consumption. Through advertising, consumerism was "sold" to those who had the means and the time to participate. The entwined fortunes of advertising and publishing persist to this day, but now photography is the illustration of choice and print is only one of several powerful media for advertising.

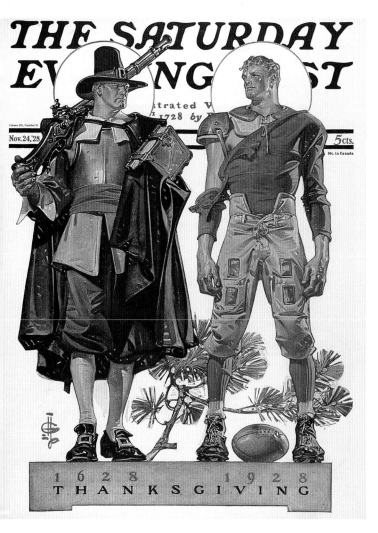

Between the turn of the century and about 1915, America discovered Childhood and Youth. The Victorian middle-class legacy of "children should be seen and not heard" gave way to the belief that children and teenagers did indeed have something to say and were worth adult investment in their futures as good citizens and responsible, self-sufficient consumers. *Boy's Life, American Boy, Youth's Companion,* and *St. Nicholas* magazines concentrated on boys and young men. Groups such as Girl Guides in England, Boy Scouts of America, Girl Scouts of America, and National 4-H Club came into being between 1910 and 1925, reinforcing a national commitment to young people.

Youth Culture, an American First

Thomas Fogarty, aware of Rockwell's need for funds, helps get him his **first paid professional job in late 1910,** illustrating a Christmas booklet. (Rockwell, an Episcopalian, pretends he is Roman Catholic to obtain the job.) The Rockwell family moves back to New York City in 1912, and before long, the artist receives $150 to make 10–12 drawings for a book for children, *Tell-Me-Why Stories about Mother Nature.* Believing himself to be on a roll, Rockwell and another student rent a "studio" in the attic of a brownstone on Manhattan's Upper West Side. His first surviving oil painting dates from this year. What the teenagers fail to notice is that the lower floors are a whorehouse. When Norman's father points this out, the guys move back home.

His gig at *Tell-My-Why Stories* gets Rockwell noticed by the editor of *Boy's Life* magazine, who quickly makes him, at age 19, its art director. It's an exciting time in New York: Grand Central Terminal opens the same year (1913) and the New York art world is host to the now-famous **Armory Show,** the first exhibition in America of modern European and American art. In three American cities, the show draws more than 300,000

paying viewers who are anxious to see for themselves what the big fuss concerning Modern art is all about. These viewers, accustomed to the traditional, representational works of artists such as Norman Rockwell— with instantly recognizable human subjects and dramatic narrative— are astounded by the radical new and perplexing forms of art. Overnight, the New York art world is wrenched from its artistic traditions and flung into Modernism. (The roots of critical disdain for Rockwell can be traced to this atmosphere of *"Let's throw old-fashioned art out the window and find something new."*)

The Urge to Succeed

While serving as art director of *Boy's Life*, Rockwell continues to contribute to such publications as *St. Nicholas, Everyland, Youth's Companion, American Boy*, and the *Handbook of Camping*. In 1915, his family moves to New Rochelle, home to many celebrated illustrators, including J. C. Leyendecker and Charles Dana Gibson. To save money and time from the commute, Rockwell and his new friend, celebrated cartoonist **Clyde Forsythe**, rent a studio that had once belonged to Frederic Remington. Here, in this frigid, corrugated-metal icebox, Rockwell struggles with his wavering self-confidence, determined to make a name for himself as an illustrator of publications for adults. (Ironically, he will always paint kids, because he loves to paint kids.) As an inspiration to himself, he paints the number **"100%"** in gold leaf on the top crossbar of his easel and devises a rating system for his paintings:

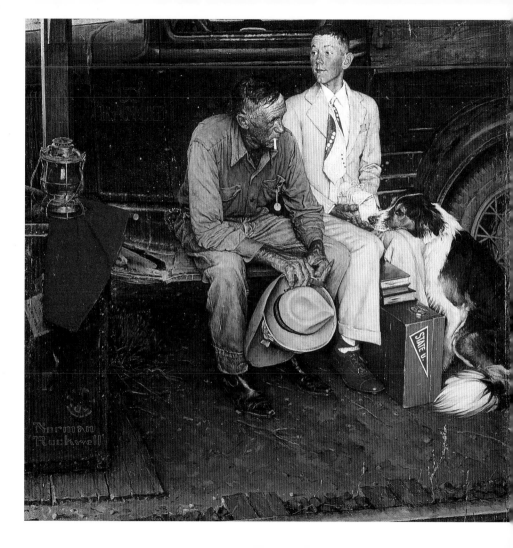

"Excellent" is the top score and "bad" is the bottom. He then implores Forsythe—who is a few years older and less intimated by the whirl of the commercial world—to make a brutally honest appraisal of each of his paintings and drawings. In return, Rockwell howls with laughter as he reviews Forsythe's comic strips.

OPPOSITE
Breaking Home Ties, 1954

I Want it all...and I want it *Now!*

Rockwell's art directorship at *Boy's Life* magazine, while still a teenager himself, is significant. He is chronologically part of the Youth Culture, though he positions himself as a spectator-cum-illustrator. While other illustrators may have been happy with an art directorship at such an early age, Rockwell tires of it quickly. He knows that churning out black-and-white illustrations for kids' publications is a dead end.

Hitting the Big Time

Adjusting his sights upward, he targets *The Saturday Evening Post,* edited by **George Horace Lorimer** (1868–1937), "the great Mr. Lorimer," whom Rockwell reveres and fears. Forsythe encourages and goads Rockwell to prepare some sketches to show Mr. Lorimer and the *Post's* art director, **Walter H. Dower.** Norman buys a new gray herringbone suit and a black hat for his March 1916 trip to the Curtis Publishing Company headquarters in Philadelphia. The sight of a behatted, bespectacled beanpole with a huge wooden box (not a baby

buggy this time) is enough to get him an audience with Dower. By the time Rockwell leaves his interview, the *Post* has purchased two covers and commissioned three more.

Marriage #1

On his way back to New Rochelle, emboldened by a check for $150 in his pocket, he travels to Atlantic City, where he promptly calls "the cutest girl" he has ever dated, **Irene O'Connor,** and asks for her hand in marriage. The schoolteacher accepts. He later calls to ask that she wire him some money: In all his excitement, he has spent his bankroll. (Of Rockwell's three marriages, this one will be the least fulfilling. The half-hearted union will last 14 years and will find the couple living separately on more than one occasion before they finally divorce.)

Sneering Bullies

Rockwell's first *Post* cover appears on May 20, 1916. (The last one will run on December 14, 1963 and will be Rockwell's 232nd cover for the magazine.) Entitled *Boy Pushing a Baby Carriage* (see page 25)—sometimes called *Salutation*—it shows two "boy's boys" taunting a third one who pushes a wicker peramulator, dressed in a suit and wearing gloves and a bowler hat that is secured to his jacket with a lapel-button bar pin. (One of Rockwell's all-time favorite models, a boy named **Billy Paine,** posed for all three characters.) The boy's face is the picture

of pain and humiliation. We feel sorry for him, because his baseball-playing tormenters mock him for being dressed up and pushing a carriage. Rockwell helps us reach back to remember the bullies in our childhood and how it felt to be taunted for doing something that seemed like the right thing to do. Notice Rockwell's attention to details: the baby's foot, a bottle sloshing with milk, a missing tooth in one of the taunters, and a flower in the well-dressed boy's buttonhole.

FYI: **Rockwell's titles**—Rockwell's paintings are often known by more than one title. This is because Rockwell often used descriptive language to "name" his paintings—as in *Girl at the Mirror* or *The Art Critic*—rather than give them precise titles. The painting on the jacket of this book, for example, is often called *Going and Coming* (Rockwell's son Tom uses this title), while the official title for it at the Norman Rockwell Museum in Stockbridge, Massachusetts, is *The Outing.* Often Rockwell's editors named his paintings.

Rockwell's first *Post* cover runs at the same time as President Woodrow Wilson announces his support for women's suffrage. In the same year, feminist Margaret Sanger is jailed for opening a birth control clinic in Brooklyn, and the French painter, **Claude Monet** (1840–1926), begins his great Impressionist mural cycle of *Waterlilies (Nymphéas).*

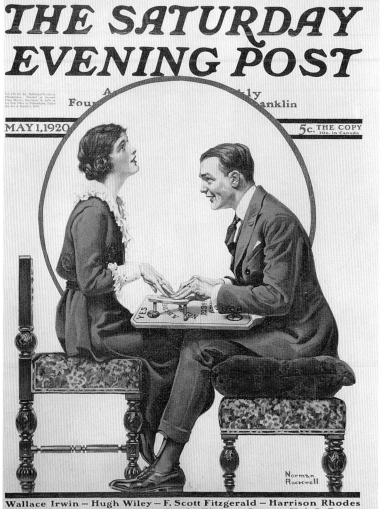

THE SATURDAY EVENING POST

Vol. 192, No. 44. Published Weekly at Philadelphia. Entered at Second-Class Matter, November 18, 1879, at the Post Office at Philadelphia, Under the Act of March 3, 1879.

Founded A.D. 1728 by Benj. Franklin

MAY 1, 1920

5c. THE COPY
10c. in Canada

**Wallace Irwin — Hugh Wiley — F. Scott Fitzgerald — Harrison Rhodes
Oscar Graeve — Henry C. Rowland — Thomas Joyce — Hal G. Evarts**

Norman Rockwell

What the *Post* Likes

During his early days at the *Post*, Rockwell specializes in scenes of young boys "in playful and cozy situations" with girls, mothers, and teachers. Later, old people join the cast of subjects, with family life and young love rounding out his repertoire. Until Rockwell paints the *Post*'s **first color cover in 1926,** his covers are always two colors (black and red). These early covers have great consistency:

OPPOSITE
Ouija Board
1920

- People are isolated against a simple backdrop or setting.

- Rarely do more than three characters occupy a composition.

- There is no "depth of field." Characters seem to float in a shallow box or on the painting's surface.

- A theme is always being acted out: an insult, a crush, naughtiness, the day's work, or a Rockwell favorite, gossip.

- The upper section of a circle often frames the top of the picture, along with two thick horizontal black rules (lines). The use of the half circle profiles the figures in the illustration and accentuates the drama taking place. It was also commonly seen in newspaper photography in those days. You can see these techniques in *Ouija Board.*

Have Idea, Will Paint

A successful artist, illustrator or otherwise, must come up with a lot of ideas, and the best of them will include come elements common to human experience. Rockwell knows that everyone worries about their own problems and that his *Post* covers can— indeed, must—unite people in their concerns and interests. His specialty is to encourage people from various backgrounds to recognize pieces of their own lives in each scenario he creates. **Humor is crucial,** since it relaxes people even when the subject is serious. But *underneath the gag there has to be some pathos,* something that readers identify with. Rockwell realizes that a joke about a sad subject keeps us looking longer. In a way, he practices a static version of the television sitcom, where a laugh keeps a dour situation from taking over.

The Far-from-Great War

A year after his Rockwell's first *Post* cover appears, the U.S. enters

World War I (1914–18), fought mainly in Europe between the Central Powers and the Allies. As horrific as it is, war becomes for Rockwell his broadest, if not most challenging, subject. Everyone is affected by **the Great War,** and yet there is a daily cornucopia of new themes to be found in newspapers and newsreels.

In 1917, he reads about the French cheering the American doughboys, so he does the scene as a cover. For authenticity, he relies on the photojournalists' images, filtering and rearranging details to come up with an accurate, if not actual, vision—and tempering it with his own gentle sympathies.

To get his paintings to press before illustrators for competing magazines turn in theirs, Rockwell sometimes works twenty hours straight (except for those three meals). Not withstanding his interest in war-related covers, Rockwell continues to produce more light-hearted fare, such as *Two Men Courting Girl's Favor* (see page 44), that remind nervous readers of life's simpler joys.

(see page 44)

Two Men Courting Girl's Favor (aka *Shall We Dance?*), 1917

THE SATURDAY EVENING POST

An Illustrated Weekly
Founded A.º D.ᵣ 1728 by ⬚ Franklin

JANUARY 13, 1917 5c. THE COPY

Guilt Sets In

In spite of his war-painting binges, he begins to doubt the size of his patriotic contribution. This prompts Rockwell to volunteer for the U.S. Navy. His first attempt is unsuccessful, since he is seventeen pounds underweight. So he packs himself with doughnuts and gains enough weight to pass the physical exam. His **tour of duty in Charleston, South Carolina** is less than arduous and not very long (1917–18). During this time, he paints insignia on airplanes and otherwise maintains the appearance of the fleet. (Many of his fellow seamen are amused to find that the gawky ship-hull decorator is a celebrated *Post* artist.)

Two days a week, he works for *Afloat and Ashore*, his camp's newspaper, and creates advertisements for Perfection oil heaters, Fiske bicycle tires, Overland cars, Jell-O, and Orange Crush. The Navy allows Rockwell to do his own work as long as it bears some relation to naval life, such as his *Post* cover of a sailor showing another sailor a picture of his girl, and a cover for *Life* magazine of a group of smiling (of course) soldiers, sailors, and marines.

BACKTRACK:
AMERICAN SCENE PAINTING

Wouldn't you expect to find Norman Rockwell in a movement called American Scene Painting? Yet he is not included, for two reasons. He was an artist firmly settled in the American Genre tradition, (see Backtrack on p. 43), and his subjects were neither specifically Regionalist (think Grant Wood's *American Gothic*) nor Social Realist (summon to mind the downtrodden populations of Ben Shahn's paintings and illustrations). American Scene was a quasi-isolationist response to the French modernism that was taunting the American art scene in the 1920s. It had already gotten its name by 1924 and the tradition continued into the 1940s with a robust **America First** that included paintings as elegant and site-specific as Edward Hopper's *Nighthawks* of 1942. With the onset of World War II, everything changed.

Norman Rockwell

THE ROCKWELL RECIPE

Rockwells look like...Rockwells. Whether magazine covers or illustrations for advertisements, all of them exist as exquisitely executed oil paintings, created after Rockwell has patiently—and brilliantly—worked them through 13 stages before applying his signature. He would:

- conceive the idea

- get it approved by the art editor

- choose his model(s)

- gather props

- pose, and later photograph, models

- do a series of small studies to work out ideas

- make a charcoal layout the size of the canvas

- do a color sketch the exact size of the final reproduction

- prepare the canvas

- transfer the charcoal sketch to the canvas

- do underpainting in spare, monochromatic strokes

- lay in color

- do the final painting with oil paints

Men with Men

Rockwell's stint in **the Navy actually proves to be a wonderful time** for him. He holds his own in the midst of a masculine world, despite his usual feelings of inadequacy and unmanliness. Swearing, brawling, and bar-hopping offer the artist a first-hand look at **rituals of male bonding,** which had fascinated him from early on, but always from the distance of an observer. (Think of the "brotherhood of young boys" images.) A few days before the Armistice is signed on November 11, 1918, Rockwell receives a discharge. He returns home to Irene in New Rochelle and resumes work with his regular clients: *Collier's, Life, Leslie's Judge, Country Gentleman, Literary Digest, People's Popular Monthly, Farm and Fireside,* and *Popular Science.* His painting for the *Post* Christmas issue inaugurates a tradition of Christmas covers that will continue for many years.

Ahhhh...Money and Fame

Rockwell's images immediately strike a chord with the American people and before long he begins to enjoy the rewards of money and public recognition. Bolstered by new resources, he can now afford to live in more affluent circumstances, surrounded by celebrated illustrator colleagues. He indulges in tennis, golf, and bridge, and buys snazzy sports clothes. Prohibition raises its head, and, like any connected socialite, Rockwell finds himself a bootlegger and parties into the next

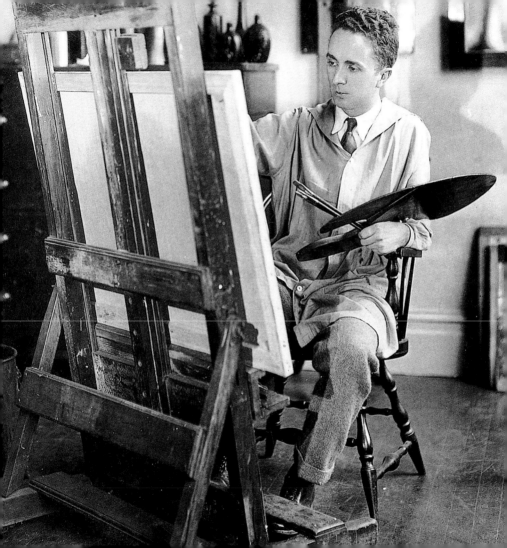

decade. (Later, he will write contritely that the behavior of adults at that time threatened the stability of the children he painted, who would often complain of their parents' frivolity.)

Feeding the Gods

New Rochelle had become a bedroom community for a number of America's most successful illustrators. Howard Pyle had once lived there. J. C. Leyendecker and his brother Frank, the reigning illustrators in advertising and creators of the Arrow Shirt Man, as shown on page 33, share a fancy place in New Rochelle. (J. C. Leyendecker was gay and it is alleged that the model for the Arrow Shirt Man ads was his lover.) J. C. and Rockwell become *the* celebs of the *Post* in an era when the magazine is giddy with success for offering "a portrait of American success, lavish, powerful, abundant" (according to *Post* biographer, Jan Cohn).

After years of driving past the Leyendecker mansion, the Rockwells summon the courage to invite the brothers over to dinner. Anxious to impress, Norman and Irene hire a chef. They figure everyone loves turkey, and even though it's July, they plan a Thanksgiving feast. Tragedy strikes when **the chef drops the turkey** in the dining room, but instead of creating a catastrophe, the hilarity of it paves the way to a wonderful 25-year relationship between Rockwell and the Leyendecker brothers. In between exclaiming how much he loves turkey, J. C. adds

that "a turkey—browned to a turn and steaming—is one of the hardest things to paint. That quality of crispness and juiciness rolled into one is almost impossible to render on a canvas." Rockwell eventually takes up the turkey-painting challenge to perfection in his *Freedom from Want* (see pages 11 and 80).

The Camera

Though Rockwell paints from live models, he breaks the traditional "no-photo" law while painting an *American Magazine* cover in **May 1921.** The reason? He is required to paint a little boy yawning, which sounds like a simple act—except the little boy has to hold his yawn for more than 30 seconds. The magazine runs a small story inside telling how Rockwell himself poses for the yawn photograph, since he is unable to get his young model to stay alertly posed once the boy is tired. This is the **first known use of a camera in Rockwell's work** and he will grow to enjoy the freedom it gives him, as well as its usefulness in recording landscapes and backgrounds for his illustrations. The camera also enables him to capture the expressions he wants by posing himself with exaggerated expressions for snapshots that he will then later show to his models.

Waiting for the Vet
1952

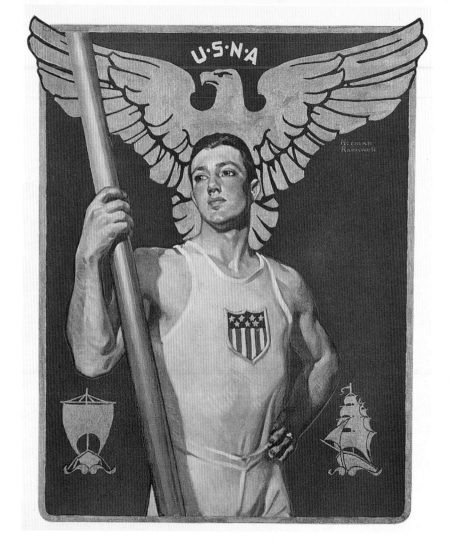

Restless Traveler

Given his peaceful temperament, his fierce love of work, and his dyed-in-the-wool Americanness, it's surprising that **Rockwell makes periodic escapes to foreign locales,** usually when he feels his work and life are getting stale—or when he feels down on himself, which is often. The first trip abroad is to South America in 1922, at the invitation of an advertising client, Edison Mazda. The next year, anxious to flee his less-than-happy marriage and stale-studio syndrome, **he sails for France without Irene** and spends weeks traveling in France and Italy with an old friend from the League and his new wife. Modernity is all around him, as is some of the best art from Western culture. Rockwell feels pulled in three directions: He wants to catch up with other artists and be modern; he derives great pleasure from studying works of the Old Masters; yet **he feels most comfortable with realism** and American subject matter.

OPPOSITE
Naval Academy Oarsman, 1921

Sex and More Sex

Just before leaving Paris for the United States, Rockwell enrolls in an art school, the Académie Calorossi, where J. C. Leyendecker had been a star pupil. A fellow illustrator, **Cole Phillips** (1880–1927), who prides himself on his rare ability to paint pretty girls, bluntly insults Rockwell with, "Old men and boys. Haven't you got any guts? You're young. Haven't you got any sex? For Lord's sake!" But Rockwell

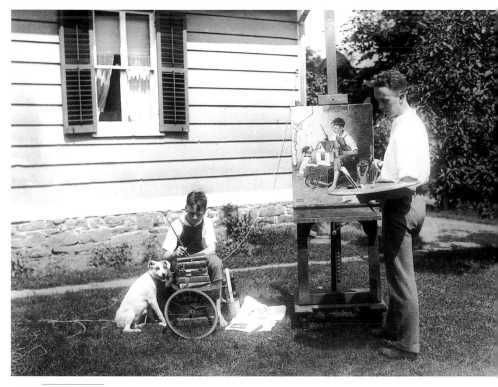

Norman Rockwell
with models
August 25, 1921

steadfastly wishes to paint only what he excells at. So what if he is less gifted than Phillips or Gibson at painting pretty girls?

Sidestepping the Modern

This is a crucial moment for him, since his art is at a crossroads and he is staring down the maw of Modernism. After eavesdropping on some "bohemian [looking] Americans," he picks up the tip that **color is important:** A new approach to color, he thinks, will make him more contemporary.

But back at the *Post*, Mr. Lorimer rejects the first "modern" cover Rockwell shows him. This is a signal to Rockwell that he should stay the course of his immensely popular illustrations. It is only in periods of crisis and self-doubt that he tends to wander.

The Old Couple
1922

Sound Byte:
"If you do something well, stick to it. Don't go off on a tangent just because people tell you you're old-fashioned or narrow....I know [modern art's] not your kind of art."

—GEORGE HORACE LORIMER, editor of *The Saturday Evening Post* from 1912 to 1936

Hobo and Dog
1924

With so much early success in life, Rockwell spends the next fifty years worrying that he might no longer be able to come up with the goods. (The eminent psychoanalyst, Erik Erikson, whom Rockwell later consults, explains that "artists like Rockwell, who are very serious and intense about their work, often tend to be greatly worried by the fact that they can't ever be sure of what they are doing.")

A Hot Property

Other magazines want what Rockwell has and they make seductive offers. In 1924, *Liberty* magazine offers him work at double his *Post* income, which creates a crisis for Rockwell. He presents his quandary to Lorimer and is asked what he'd rather do. Rockwell responds, "I'll stay with you, Mr. Lorimer," whereupon Lorimer immediately doubles his salary.

FYI: Norman Rockwell was fond of his name. And as his popularity increased, so did his signature. It grew from Norman Rockwell to NORMAN ROCKWELL. "Make it as large as you like," said Lorimer, "but not larger than the title of the magazine." Sometimes his signature appears in handwritten script; at other times, it looks like a corporate logo that has been stamped onto the canvas.

Good Scout

The *Post* may have made Rockwell a star, but the Boy Scouts of America, founded when Norman was 16 years old, are his passion. His chance to be a good Scout comes in 1924, when he creates his first Boy Scout calendar. From 1924 to 1974, in all but two years, he will paint calendars for the organization. At this stage in Rockwell's career, calendar art is big business, since it's an easy way for companies to advertise their image. But after World War II, their popularity wanes as the public's fondness for photography replaces "the quaintness of drawings."

Boys, not Girls

Rockwell's predilection for painting boys instead of girls lasts a long time. Perhaps it's an opportunity to enact the carefree boyhood he longed for and never had. But he is aware that this preference places him in a delicate situation: "For days I'd hang about the grade schools at recess, peer over the fences into backyards, haunt the vacant lots, and stop little boys on the street, turning them around and sideways to see if they were the type I wanted." Today, of course, this kind of behavior might raise an eyebrow; but then, only girl models required a chaperone, and Rockwell's reputation for clean American fun was so spic and span that even girls could pose on their own. His favorite subjects, in descending order, are boys, old people, girls, and teenagers.

Posing His Models

Rockwell uses children and animals with and without the benefit of a camera or a photographer to take the pictures for him. Through trial and error, he evolves a few tricks for "posing" his models:

- **A chicken:** Pick it up, rock it back and forth a few times. When you put it down, it will stand still for five minutes.

- **A duck:** You position the duck just where you want it and then you nail it to the floor. As a farmer once told a squeamish Rockwell (the city boy): "You could pound a railroad spike in the web of his foot and he wouldn't blink an eye."

- **A child:** Since you are not allowed to spin children around or nail them to the floor, you can pay them 50 cents an hour. For boys who are less eager and less patient than girls, Rockwell suggests making a pile of nickels, then moving one onto the boy's pile every 10 minutes to show how his pay is adding up.

- **A dog:** Get an old one.

Reality check: Flush with success, Rockwell is 33 years old and is a member of The Larchmont Yacht Club and The Bonnie Briar Country Club. The undisputed *King of Covers,* he builds himself a $23,000 studio and lives the suburban highlife. And yet he is unhappy.

Bye, Bye, Mrs. American Pie

Between 1927 and 1929, a lonely Rockwell makes two solo escapes to Europe, staying at some of the continent's grander hotels. Back home, the stock market has crashed and the socially perky Irene Rockwell, rarely interested in her husband's work, has fallen in love with someone else. After 14 years of marriage, the promoter of family life is divorced from his wife in 1930.

Miserable, he moves to the fittingly named apartment building, Hotel des Artistes, on 67th Street off Central Park West, in New York City. He is a bachelor once again and unhappy. In an effort to get away from it all, he travels to Los Angeles and meets up with his old friend Clyde

Dog Biting Man in Seat of Pants 1928

Forsythe. Rockwell hangs out with the Hollywood crowd and paints a number of celebrities, including the actor Gary Cooper, who is being made up that day on the set of a Western.

Marriage #2

While the Southern California sun and fun draw Rockwell out of his funk, it is a date with **Mary Barstow,** a schoolteacher he will marry in April 1930, that makes the trip a success. He and Mary will remain devoted partners until her sudden death in 1959.

> **FYI:** After their marriage, Rockwell paints Mary with in a wistful pose for a *Post* cover (on p. 61) that depicts a husband and wife at breakfast. Mary soon receives a letter from a friend, offering condolences. From the picture, she had assumed that Mary is in a terribly unhappy marriage!

The happily remarried Rockwell finds the early 1930s not as easy as the 1920s had been. He himself points to one work, a *Post* cover from January 18, 1930, where he had actually painted three legs on a boy—a sign that he was in the middle of an emotional and artistic breakdown.

Back to Paris

By 1932, he is yet again in the midst of a harsh funk and sets out once more to Paris in search of inspiration, this time with Mary and his

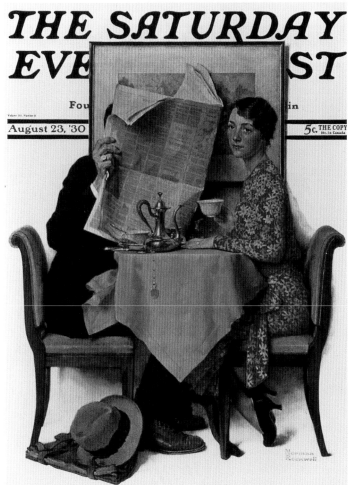

The Breakfast Table, 1930

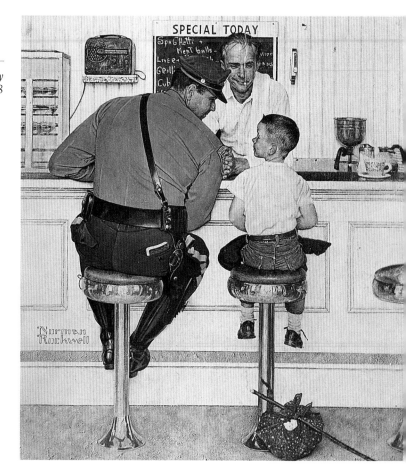

newborn son, **Jerry (Jarvis)**, at his side. He has heard about the artistic innovations that have come from the studios of Braque and Picasso over the past 20 years. He sees good works by the Futurists, Expressionists, and Surrealists, and is amazed by the whirling vortex of possibilities. For a wildly successful artist, Rockwell remains disheartened that he cannot be counted among the avant-garde. He tries "modern" paintings, but everything he submits to his loyal publishers is rejected.

Sound Byte:

"My best efforts were some modern things that looked like very lousy Matisses. Thank God I had the sense to realize they were lousy and leave Paris."

—NORMAN ROCKWELL, to Rufus Jarmen of
The New Yorker

After seven unfruitful months of experimentation, Rockwell takes his family home. The frantic pace of coming up with complex covers for the *Post* weighs heavily on him, so Rockwell decides to look for illustrating work other than Boy Scout calendars and magazine covers. His second child, **Tom Rockwell,** is born in 1933.

Tom and Huck

The sun shines in 1935, when he begins his extraordinary illustrations for *Tom Sawyer* and *Huckleberry Finn.* He goes to Hannibal, Missouri,

certain that no previous Tom and Huck illustrators have ventured there, and tours the actual sites that inspired Mark Twain, sucking up details. He even goes so far as to buy old clothes from some of Hannibal's residents. (In the same year, he does a cover of a mother introducing her son to his teacher. But he inadvertently dresses his characters in clothing from the 1870s. This picture gets the dander up of a lot of schoolteachers who feel Rockwell has portrayed them as dowdy old pusses.)

Sound Byte:
"I've made it a rule never to fake anything, always to use, if possible, authentic props and costumes. I feel that no matter what the quality of my work is, at least it won't be dragged down by fakery."
—NORMAN ROCKWELL

Art for the Walls

Rockwell's passion for authentic costuming hits an all-time high in 1937 when he commissions a tailor to make a set of military uniforms. The painting he wants them for—actually a mural—is *Yankee Doodle* for the Nassau Inn in Princeton, New Jersey. Rockwell's one and only mural is not for a public building. He does not need the money. In fact, his fortunes are little affected by the Great Depression. He accepts the Inn's commission and paints his *Yankee Doodle* theme animated by (you guessed it) detail and lively interaction of the characters. The mural's

64

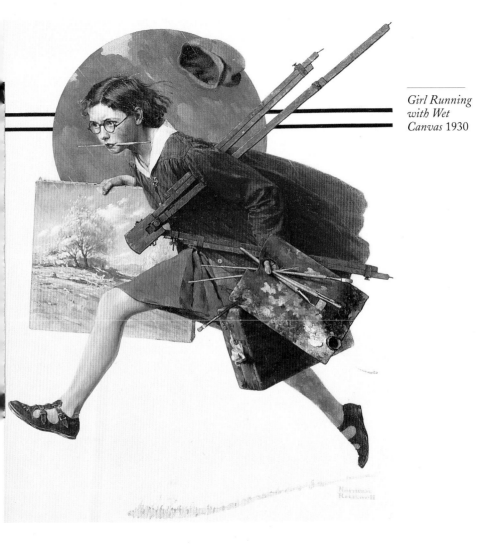

Girl Running with Wet Canvas 1930

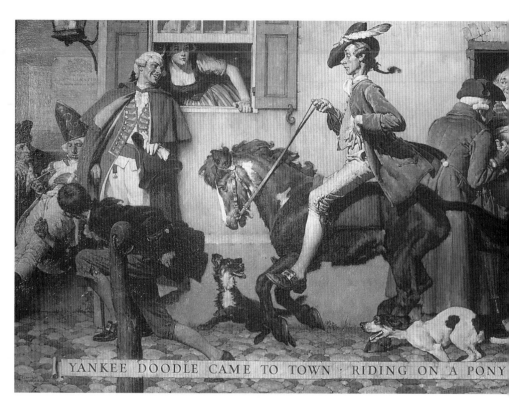

YANKEE DOODLE CAME TO TOWN · RIDING ON A PONY

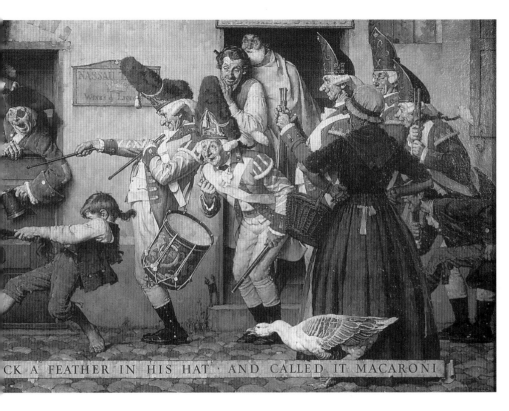

Yankee Doodle
1937

Murals had been for centuries a standard part of interior decoration, especially in public places. Ironically, murals and posters resurged as favored media in the mid-1930s because of the Great Depression. As part of his New Deal, President Roosevelt created a number of social-welfare programs beginning in 1935, including the Social Security Act and the Works Progress Administration (WPA). One of the WPA's several arms, the Federal Arts Project, employed out-of-work artists to paint murals in public buildings. Artists such as **Jackson Pollock** (1912–1956), **Willem de Kooning** (1904–1997), and **Arshile Gorky** (1904–1948) were sustained through very hard times by such commissions.

pomp-and-circumstance earnestness gives it a look that borders on historical camp.

The Old Guard Falls Away

When George Lorimer retires as editor of the *Post* in 1936, Rockwell loses his most ardent supporter. Wesley Stout takes over, and Rockwell's always-just-below-the surface insecurities rise to the top. Lorimer had been quick to let Rockwell know where he stood. Stout is hard to read and even harder to please: a pair of shoes has to be painted two or three times before Stout accepts a painting as finished. This change occurs in the same year as the Rockwells' third and last son, **Peter**, is born.

It's a busy time in the world. The year 1937 sees two million Germans visit a Nazi-sponsored exhibition, "Degenerate Art," which includes Van Goghs and works by German Expressionists, Dadaists, Surrealists, and Cubists. Another show, "Great German Art," which runs concurrently, shows nationalistic images in a muscular, realistic Socialist style and draws only 60,000 visitors. In America, the Golden Gate Bridge opens in San Francisco; Spam is introduced to the market; and **Frank Lloyd Wright** (1869–1959) designs Fallingwater,

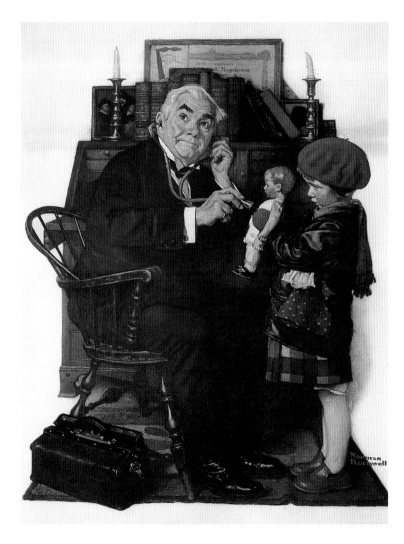

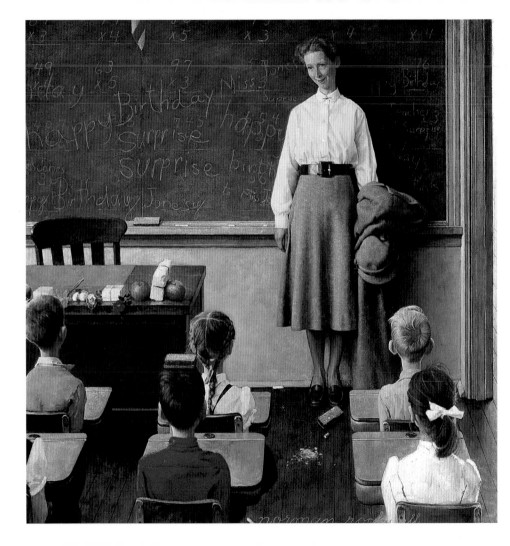

a modern masterpiece of domestic architecture in rural Pennsylvania. It's also the year in which Picasso paints his famous anti-war canvas, *Guernica,* in protest against the savage bombing by Germans of Guernica, a town sacred to the independent-minded Basques of Spain.

Get Over It!

Rockwell's 1921 experiment with self-photographing had been an isolated one. But with three little boys in the house, **the camera comes in handy** for capturing all the cute candid moments. For artists of Rockwell's generation, using a camera bordered on plagiarism. Still, Rockwell finds a move to photography necessary. First, models are getting harder and harder to find. Second, if he wants to show "ordinary people," it works better to take their pictures than to ask them to pose for whole days at a time. Third, photography gives him a chance to play with angles of view. (An art director had told Rockwell that his models all looked like they were sitting on chairs placed exactly ten feet away from the artist.)

By 1937, he feels at ease with the camera—even liberated by it—and now uses it as an integral part of his process. Even so, he feels like he's fudging, and when visitors come to the studio he puts the photographs out of sight.

Rockwell's principles of photography-in-the-service-of-art are:

Happy Birthday, Miss Jones (aka *Teacher's Birthday*), 1956

1. He uses an average of 100 photos to make his sketches.

2. Photographs are only to be used as aids.

3. Photographs enable portraiture when the sitter is a busy person.

4. Photographs help him capture a certain desired lighting.

How is his art affected? Compare for yourself paintings from before and after 1937. You will find that:

- Silhouetting disappears.

- There is more specific detail in backgrounds, especially in depicting buildings.

- He employs a more cinematic approach to the composition, which suggests action occurring outside the pictorial frame.

- There is greater variety in his use of perspective and of smaller spaces within spaces.

Sound Byte:
"All in all, I feel justified in using photographs. Not so cleanly justified, however, that I don't squirm and grin sheepishly when someone mentions it. But I don't think it's changed my work. I challenge anybody to show me when I started to use photographs. I've always been known as The Kid with the Camera Eye.*"*

—NORMAN ROCKWELL

With their oldest boy only six years old, the Rockwells set out in 1938 for another trip abroad, this time to England. The country lanes of Oxford make him long for a more rural home base. After their return, the Rockwells purchase a summer home in **Arlington, Vermont,** close to a number of other illustrators and artists, including **Grandma Moses** (1860–1961). One summer later, delighted with their new locale, they make a permanent move to Arlington.

Willie Gillis, We Really Knew Ya

Rockwell may be in rural heaven, but clearly he is aware that a war is being fought overseas. World War II is a turning-point experience for Rockwell, who is 45 years old when Germany invades Poland. During the next six years of that horrible war, Americans rely heavily on photographs for their information about the grisly battlefield scenes. Rockwell, who spurns the photo-documentary approach, creates instead the character of an appealing, all-purpose GI, whom he tags **Willie Gillis,** through whom the artist can explore the theme of *leaving and coming home*. GI's are the working stiffs of the World War II military. Without a commission and rarely self-enlisted, typical GIs are hometown boys, uprooted from their

Norman Rockwell
November 28, 1939

communities and shipped off to Europe like cattle. Rockwell's Willie Gillis is the boy next door, the mother's son, the sister's brother. (Actually, he is Bob Buck, a boy Rockwell spots as his ideal model at the local Grange Hall.) Willie's short frame and gosh-and-golly face encourage the protective instincts of women (magazine readers). The story of Willie Gillis also gives Rockwell a chance to develop a theme in successive *Post* covers, something he has not been able to do for many years. **The theme of leaving and coming home** is artfully, even tenderly, explored in a total of eleven Willie Gillis *Post* covers, including Willie's departure, peeling potatoes for his fellow soldiers, picking up a CARE package, consuming the "Home Town News," and finally returning home and to college on the GI Bill. Rockwell's intention is *to humanize the war,* to aid and comfort families with sons and daughters who are "over there," to acknowledge the whole range of human sacrifice, and generally to bolster morale on the home front during the war. Willie Gillis becomes so real for Americans that they write to Rockwell asking for the young man's address.

In *Package from Home,* Rockwell shows a sensitive, more touching side of war, if such a thing exists. He has little interest in depicting the harsher realities of military service, perhaps out of a sense of sympathy for the families left behind. He seeks an image of the war that brings some measure of comfort to family members waiting nervously in America for their loved ones' return. Willie Gillis shows the folks

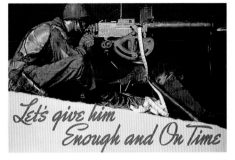

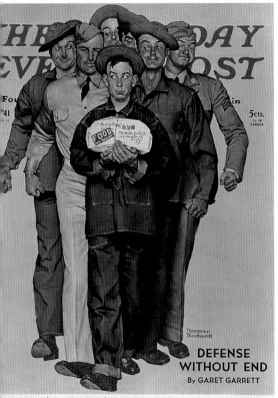

ABOVE
*"Let's give him
Enough and On
Time,"* 1942

LEFT
*Package from
Home,* 1941

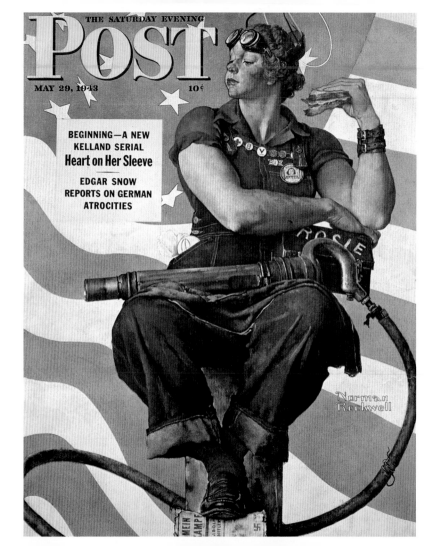

back home **the daily routine of soldiering** and leaves the bloodshed to the photojournalists. Rockwell creates these paintings against a backdrop of a very busy year for Americans: The first commercial TV programming appears in the United States; Mount Rushmore National Monument in South Dakota is opened to the public; Pearl Harbor is attacked by the Japanese; and Orson Welles makes his monumental film noir, *Citizen Kane.*

OPPOSITE
Rosie the Riveter
1943

To show his sensitivity to the war effort and his awareness that war is brutal, Rockwell creates *Let's give him Enough and On Time,* (see page 75), an unusually stark poster for the artist, both thematically and in its tone. The threatening title and anonymity of the figure create a dark, menacing view of the war. The poster is less about Rockwell and his vision than about the state of things during the war. The violent slash of yellow that tears into the dark night resembles a Hollywood movie poster. It is as macho as Rockwell gets.

Rosie, We Love Ya'

Willie Gillis's female counterpart, Rosie the Riveter, seen only once, is the iconic cover image for the *Post* issue of May 29, 1943. Muscular and powerful, she is posed like Michelangelo's prophet Isaiah in the ceiling of the Sistine Chapel, with a huge riveting gun lying across her lap, an elbow and forearm resting on her black lunch pail (marked with the name ROSIE), her dark-blue bib overalls decorated with a line of

patriotic buttons, and her loafered feet tromping a dirty copy of Hitler's *Mein Kampf*. The backdrop of the painting is the American flag, a sure sign from Rockwell that the growing importance of women during wartime America is a good thing for the country, a source of strength to the nation. While Rockwell may have painted more famous women in his career, none has more notoriety or is a greater crowd-pleaser than Rosie, an Everywoman for America.

Four Freedoms

Wrestling with guilt over his status as a prosperous American ensconced in the safety of his home (he is too old to serve) while the country is engaged in a gut-wrenching global war, Rockwell longs to contribute something substantial that will aid the war effort. At 3:00 AM on the night of July 16, 1942, Mary Rockwell awakens from a deep sleep to find her husband wide awake, excited about an idea that has just occurred to him: He will create a series of illustrations for the U. S. government based on President Roosevelt's "Four Freedoms" speech, his annual address to Congress that year: they will include *Freedom of Speech, Freedom of Worship, Freedom from Fear,* and *Freedom from Want* (see pages 80-81). The four images in tandem will unite Americans in their common goal of democracy for all.

Freedom From Want is the universally recognized portrait of Americana. It is the single most representative image of a kind of America known

around the world as the apple-pie-eating, turkey-carving, wishbone-splitting, granny-knitting home. It is one of Rockwell's most beloved paintings, but, ironically, his least favorite of the suite.

Freedom of Speech features a man with a simple quest: the right to be heard. The model Rockwell uses for this image bears some resemblance to the actor Gregory Peck, who portrays the freedom-championing lawyer Atticus Finch in the movie *To Kill a Mockingbird.* The simplicity in which Rockwell pictures the ability to be heard reminds one of the actor Jimmy Stewart's earnest proclamations in the movie *Mr. Smith Goes to Washington.* Note the deep black rectangle that frames the speaker's face. Without it, the speaker would blend into the crowd.

Freedom of Worship is the most difficult of the quartet, since religion is a tricky subject to paint. Rockwell is afraid of stereotypes, yet he wants to show freedom of religion for all people. His use of the extreme close-up conveys a message of urgency and intimacy.

Freedom from Fear is, for many viewers, the most comforting of the four, yet many critics find it strangely smug, as if this portrait of an American couple tucking their children safely into bed fuels American isolationism. *("We don't have to worry like the Brits do about being bombed.")* This is not Rockwell's intent.

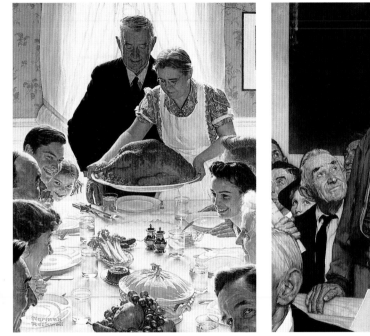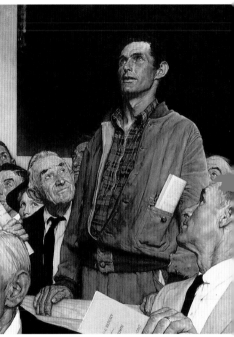

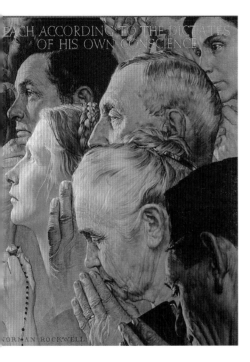
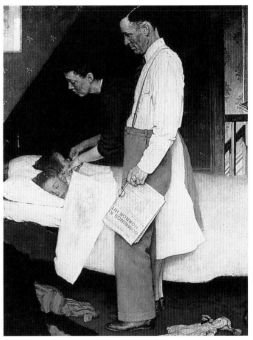

LEFT TO RIGHT
Freedom from Want, 1943
Freedom of Speech, 1943
Freedom of Worship
(aka *Freedom of Religion*) 1943
Freedom from Fear, 1943

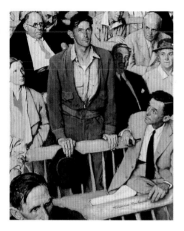

A study for
Freedom of Speech
1943

Big ideas create big problems, and, for a time, it seems that Rockwell cannot give his *Freedoms* away. He goes from governmental agency to agency, sketches in hand, looking for an official to accept his donation. The Pentagon turns Rockwell away with his four treasures, arguing that they don't have time for posters just now. The *Post*'s new editor, Ben Hibbs, runs the large (44 x 48") paintings early in 1943, each with an essay by a well-known writer. **They are a huge success and millions of them are reprinted as posters.** The war in Europe and Japan is not going well for the Allies, and these monumental, deeply felt Rockwell images bolster national resolve and help restore the conviction that America is engaged in a noble cause that is worth fighting for.

Requests for reprints pour in. Rockwell himself receives more than **70,000 fan letters from grateful Americans.** The Treasury Department buys the original, king-size

Sound Byte:

"In the future days, which we seek to make secure, we look forward to a world founded upon four essential human freedoms:

The first is freedom of speech and expression, everywhere in the world.

The second is freedom of every person to worship God in his own way, everywhere in the world.

The third is freedom from want, which, translated into world terms, means economic understandings that will secure to every nation a healthy peacetime life for its inhabitants, everywhere in the world.

The fourth is freedom from fear, which, translated into world terms, means a worldwide reduction of armaments to such a point and in such a thorough fashion that no nation will be a position to commit an act of physical aggression against any neighbor, anywhere in the world."

—FRANKLIN D. ROOSEVELT, "Four Freedoms,"
in his annual address to Congress, 1942

paintings, tours them (with Rockwell himself) to 16 cities, and raises $132,992,539.00 in a highly successful war-bond drive. Eleanor Roosevelt reviews the *Four Freedoms* over the radio and Rockwell becomes a national hero. In the process, his weight drops from 136 to 125 pounds during the ten months he works on the paintings. The *Four Freedoms* are reprinted more often than any other Rockwell images. At the time, the office of war information alone prints four million sets.

Meanwhile, back in Vermont, Rockwell experiences every artist's worst nightmare: **His studio tragically burns to the ground in 1943.** Gone are 30 paintings and many decades' accumulation of props and costumes. Rockwell's only known comment is, "There goes my life's work." But the fire might be seen as a blessing in disguise, since it provides Rockwell the impetus to rid himself of the baggage of almost 30 years and orient himself to the future. **At 49, the artist must reluctantly start anew.** Instead of painting the days of yore, he now decides to capture the more contemporary world around him, even if it's still a little rural.

After the War

Prior to World War II, Rockwell had said (and many historians would agree) that there was no separation between the past and the present; there was only one continuous flow. Yet the experience of World War II and the burning of his Arlington studio interrupted the flow of Rockwell's life and his connection to the past. Looking back with nostalgia to an epoch of innocence seems a luxury not quite appropriate in the immediate postwar years, when individuals and families are constructing new lives and America is coming to grips with its status as a superpower in a new age.

The old historical period pieces are impossible to paint now that the stash of milking stools, roller skates, and capes and bonnets have

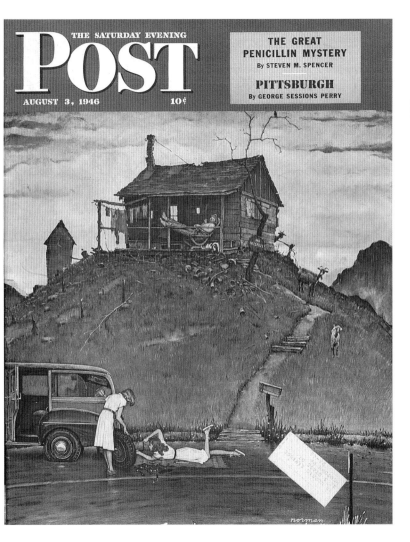

Fixing a Flat
1946

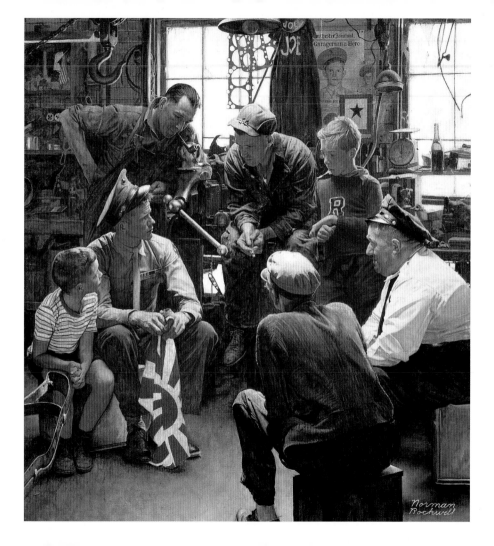

LEFT
Willie Gillis in College, 1946
(Note the dreaded swastika and helmet of a German soldier that Willie brought home as trophies of victory.)

OPPOSITE
Homecoming Marine, 1945

burned to ashes. Instead of turning back, **Rockwell focuses on archetypal everyday activities taking place in small-town America:** the country school, the small-town newspaper office; the rural family doctor, even the agricultural agent. The mandatory camera takes the place of the old costume collection, documenting what the doctor wears and what instruments he keeps out on the table.

At the *Post*, the times they are a-changin'. Ken Stuart becomes the new art editor at the *Post* and sets the tone for a new direction: the literal

portrait of America, a collective portrait that includes everyone. Stuart believes **the *Post* covers have become stale and stereotyped** and decides that the magazine needs to find innovative ways of expressing the energy and complexity of postwar America. Rockwell is asked to paint what he *really wants* to say and not what he thinks the new editor and art director expect from him. His work now focuses more on the cultural environment of the events he shows. *He gradually replaces theater with mood and emotion.*

A fine example of this new style is *Shuffleton's Barbershop*, the April 29, 1950 cover of the *Post* and **one of Rockwell's most memorable images.** In this painting, a series of windows and doors creates four separate spaces. The dramatic lighting (courtesy of the camera) turns a homey barber shop into a sanctuary. Rockwellian details are plentiful here: the crack in the window, a missing drawer, the chipped baseboard, a mug in the sink which signals the last shave of the day. The camaraderie of the musicians is everything Rockwell loves about life in a small town, but their humanity saves the picture from being saccharine. The eerie dark space beyond the left-hand window is accented by the somewhat straggly black cat's gaze.

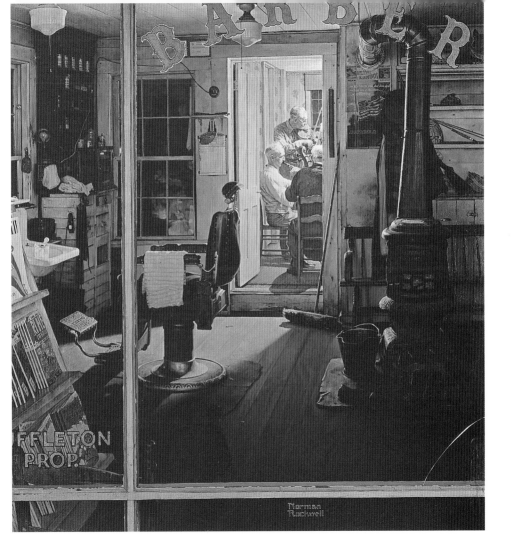

Norman
Rockwell

But the bright ochre tones in the background warm the heart of most viewers. The novelist John Updike liked it enough to hang a copy of it in his office bathroom.

FYI: **A business boo-boo—**In 1948, Rockwell co-founded the Famous Artists School, a correspondence course that promised instruction and response from teachers the likes of Rockwell. "Draw Me!" read the headline in the full-page ads next to a caricatured profile of a woman. Famous Artists School was so successful that it failed: Students signed on and stayed on longer than the co-founders thought they would, and it cost the artists more to critique their students than revenues could support.

Stockbridge, Here We Come!

In 1951, after painting the wonderfully endearing *Thanksgiving (Saying Grace),* shown on p. 22, in which a grandmother says Thanksgiving grace with her grandson in a cafeteria (it's his most popular *Post* cover, published on November 24, 1951), Norman and Mary find themselves increasingly tormented by their struggle with alcoholism (Mary) and depression (Norman). In 1952, he paints a portrait of President Eisenhower, thus beginning a **tradition of painting presidents** and first ladies every four years. Finally, in 1953, the couple can no longer continue to battle their individual illnesses. In search of help, they look to the Austen Riggs Center in Stockbridge, Massachusetts.

A New Direction on the Horizon

Stockbridge is the American town most identified with Rockwell. He and Mary move there in 1953 to facilitate their medical treatment, and Rockwell has the good fortune to meet psychoanalyst **Erik Erikson** (b. 1902) there. The analyst, whose clinical specialty includes research on "identity crisis" and on racial prejudice, treats Rockwell for depression and has a great influence on the artist's choice of subject matters in his paintings of the 1950s and 1960s. Stockbridge might just have easily been dreamed up by Rockwell, for it is a true small hometown. After living many years in big cities and rural settings, Rockwell now finds a steady road, thriving on light, non-intrusive social contact and enjoying the chitchat with local shopkeepers and farmers. As newcomer in town, *he becomes Stockbridge.*

Erik Erikson
1962

Having been told by Lorimer not to include "colored people" in his paintings, Rockwell feels held back in his desire to depict all Americans, regardless of race. Erikson's 1950 book, *Childhood and Society,* develops the argument that black children who grow up in a white (ergo, racist) society end up hating themselves and suffering from loss of identity. Rockwell knows, from first-hand experience, that blacks are discriminated against: A few years earlier, an editor at the *Post* painted over a significant detail in one of Rockwell's paintings without informing the artist—a not-so-subtle form of racism that causes Rockwell to be wary of the white establishment.

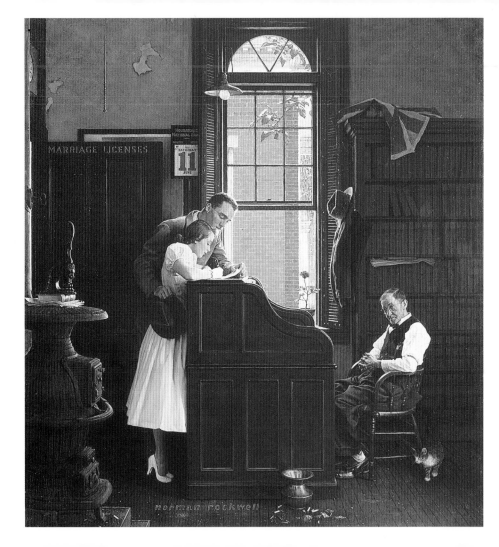

The Rockwells purchase a Federal-style house with carriage house (for his studio) in 1957, at the same time as the artist is attacked in *Atlantic Monthly* magazine for ignoring Modern Art and for being irrelevant. Mary dies suddenly of a heart attack in 1959, but Rockwell stays on and oversees the formation of the original Norman Rockwell Museum.

Marriage #3

A year later, the *Post* serializes his memoirs, as told to his son Tom, and they are published the same year in book form as *My Adventures as an Illustrator.* In 1961, he marries **Molly Punderson,** a retired school-teacher whom he meets in a class on modern poetry. He just *loves* those schoolteachers, doesn't he?

One More Look at the Moderns

For every ten people who have heard of Jackson Pollock and his drip paintings, more than 1,000 know Norman Rockwell and his Christmas cards. Rockwell loves the mass appeal of his work, but also enjoys the art of Jackson Pollock, who died in 1956. In yet another attempt to try his hand at modern art, Rockwell creates a painting, *The Connoisseur*, in 1962, in which a curious viewer stares at a drip painting that hangs on a museum wall—and that looks strangely similar to a canvas that Pollock might have created. (Not surprisingly, Rockwell makes several drip paintings in his studio to learn what the process feels like.) The

ABOVE
Norman and Molly Rockwell
1967

OPPOSITE
The Marriage License, 1955

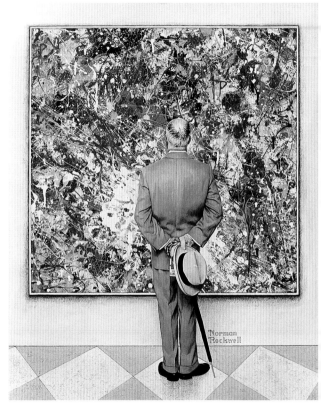

ABOVE
The Art Critic
(aka *The Critic*)
1955

RIGHT
The Connoisseur
1962

painting is a wry comment on art snobs who express contempt for anything that is not trendy or in vogue. The work is also an act of homage to the AbEx painter Rockwell most admires.

Though he is a product of an older generation, Rockwell adapts astonishingly well to change. He rides into the 1960s, ready for renewal. He and John F. Kennedy get on splendidly, and Rockwell paints several portraits of the president. (He also paints Presidents Eisenhower, Nixon, Johnson, and Reagan and presidential aspirants Adlai E. Stevenson, Barry Goldwater, Robert F. Kennedy, and Hubert Humphrey.)

With the emotional support of his physician and the staff at the Austen Riggs Center, Rockwell makes the decision to part company with the *Post* after 47 years. His final cover for them is published on December 14, 1963.

Sound Byte:
"There was change in the thought climate in America brought on by scientific advance, the atom bomb, two world wars, and Mr. Freud and psychology. Now I am wildly excited about painting contemporary subjects...pictures about civil rights, astronauts...poverty programs. It is wonderful."
—NORMAN ROCKWELL, in a speech about his turn to activism, 1963

John F. Kennedy
1960

No sooner does he leave the *Post* and its cheery world of middle-class white America than he is snapped up by *Look* magazine in 1964. They encourage him to focus on social and political issues, and no where is this better expressed than in his painting about school integration, *The Problem We All Live With* (on the next page). In the first part of his career (while working for the *Post*), Rockwell portrays an America coping with the bittersweet realities of day-to-day life. In the second part, he becomes an activist against racism and a supporter of space exploration, the Peace Corps, and of worldwide efforts to bring about harmony among people. That's a remarkable feat for someone who was under orders at the *Post* (from Mr. Lorimer) to paint African Americans only as servants. While it is a *popular* thing to paint the first American landing on the moon, it is a *courageous* thing to paint desegregation, as in *New Kids in the Neighborhood* (pages 100-101), and bloodshed in Mississippi, as shown in *Southern Justice* (page 102).

> **FYI:** According to son Tom Rockwell, his father was most committed to two major causes: the Nuclear Test Ban Treaty and civil rights for African Americans. Working for these causes brought the artist enormous gratification.

In the early 1970s, Rockwell's stock with the art community drops even further. The critics perceive him as being old-fashioned and passé, and pan the 60-year retrospective of his work at New York's

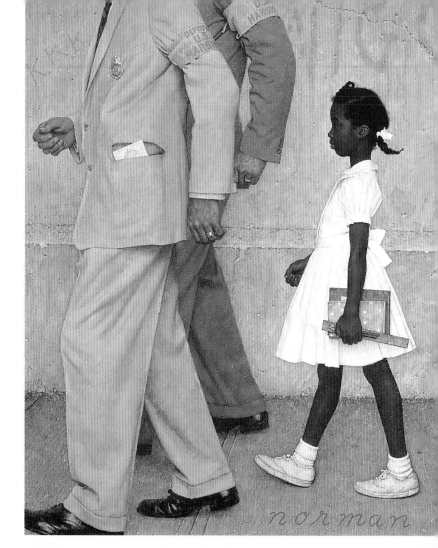

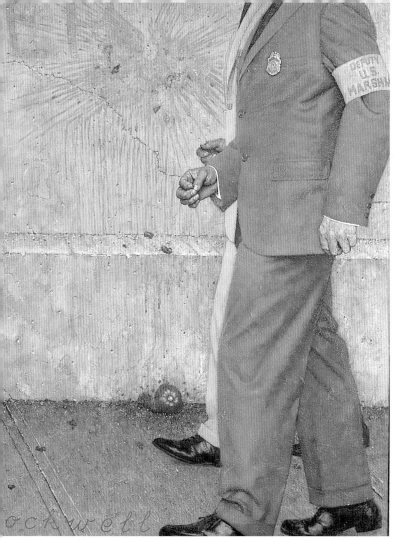

ockwell

The Problem We All Live With
1964

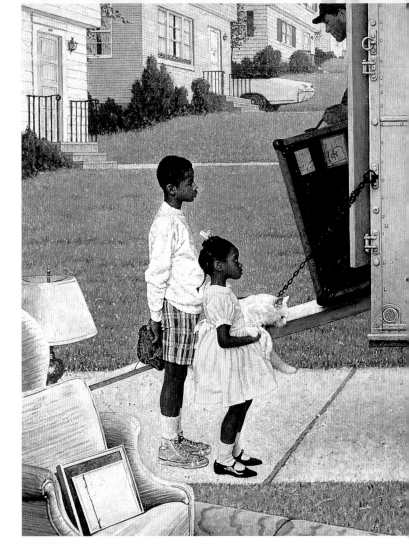

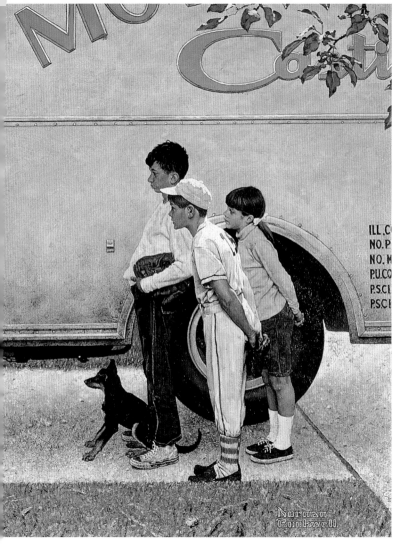

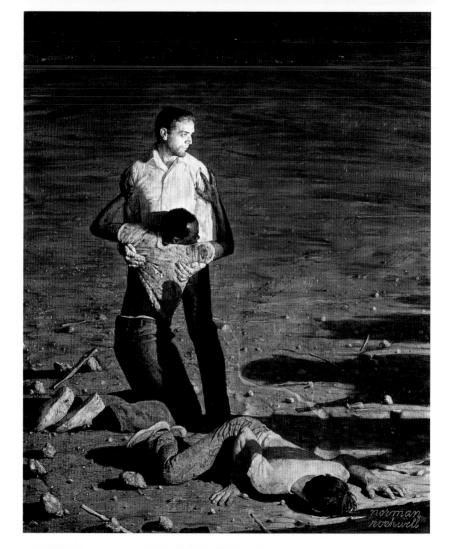

Danenberg Gallery. The high-brows may think they've won the day, but for Norman Rockwell's fans, it's the *critics* who are irrelevant.

The irony is that Rockwell is now back for another round of applause and appreciation in the 21st century. Time has bestowed the gift of perspective on his work and, with refreshed eyes, we see:

OPPOSITE
Southern Justice
1965

- an artist possessed of great aesthetic sensibilities and technical bravura

- an oeuvre of staggering size and almost uniform excellence

- dedicated attention to detail that never overwhelms the larger importance of a work, which is the story he is telling or the meaning of that story

- a steady and infectious conviction that human beings are fundamentally good

The world-famous artist and beloved pop-culture figure dies quietly at home in Stockbridge on November 8, 1978 at the age of 84.

The Essential Norman Rockwell

Rockwell was a Horatio Alger figure, driven by a need to work work work and by an ambition to excel, to compete intensely with himself. Like the original **Horatio Alger, Jr.** (1832–1899), known for his 100+ books for boys in which the young heros overcome large hurdles

and become big successes, Rockwell's *self-reliance and hard work* earned him this kind of success. He was principled, orderly, and logical. Ironically, he was also haunted by insecurity about his ability to paint well and to keep coming up with good ideas.

OPPOSITE
Girl with Black Eye, 1953

He was a figurative painter—that is, **a painter of people.** No other subject ever got his attention. He observed the individual with a keen eye, and was a quiet and profound observer of human nature. He lived much of his life during America's age of innocence, and he lived long enough to see its plunge into violence and turmoil. He knew that humankind has a dark side, but he chose never to depict rage or brutality, only the results of it. He meant his work to bring out the best in us—to mirror kindness, tolerance, humor, and trust in one another, so that we might connect as members of a harmonious human family.

Paradoxically, Rockwell's art transcends its human subject matter, balanced compositions, perfected drawing and painting techniques, and the countless details of America's material culture, precisely because it celebrates these things. In freezing the telling moments and in "proving" that they actually happened by including lifelike objects from our daily existence, Rockwell's paintings and drawings, book illustrations and magazine covers, remind us that everything is always changing, that nothing lasts forever or even longer than an instant. This moment is all there is, and it is priceless.

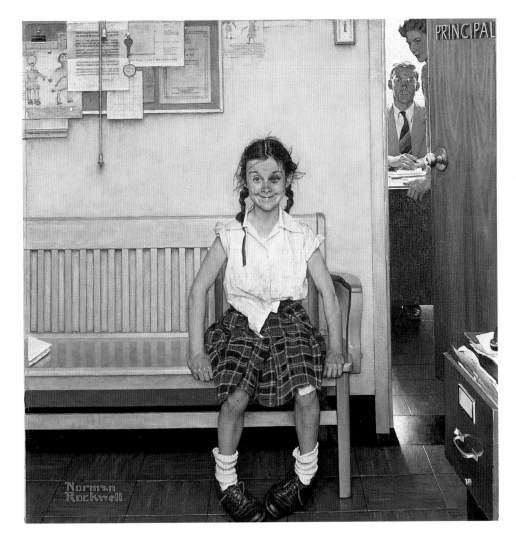

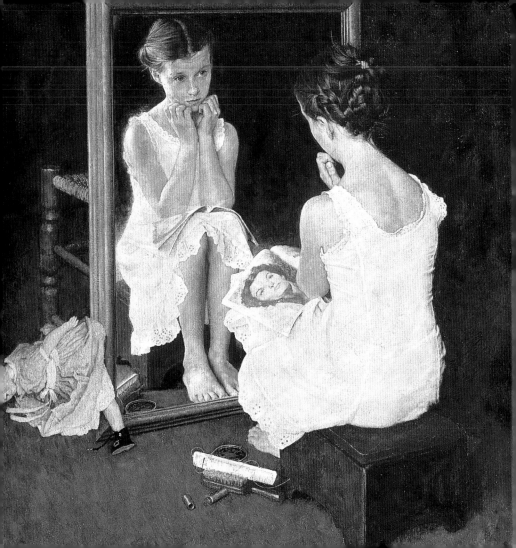

A Special Greatness

Part of the fascination with—and importance of—Rockwell as an artist is that in significant ways, *the content of his work evolved over time.* (The word *content* is used here to mean not just the subject matter of a picture—for example, a bashful teenage boy with flowers for his date—but the way the subject is interpreted and how that interpretation contributes to the larger meaning of a picture.) Rockwell was far more in tune with the times he lived through than we sometimes give him credit for. He acutely observed sociological and societal shifts and changes for nearly 50 years, and he recorded and explained the changing expressions of his country's middle-class values in a number of thematic categories, including: school-age boys and girls; dating and courtship behaviors; women as women; home and family; marriage; sports and leisure; work life and careers; the military.

Young Girls and Women

Throughout his life, Rockwell was a shrewd, empathic observer of gender, especially female. For a man with no sisters and a mother who was paralyzingly depressed, he had a deep and subtle comprehension of what it was like to be a young girl—the expectations placed on her; her absorption or rejection of "feminine" behavior; passages of self-doubt and self-knowledge. From *Girl Running with Wet Canvas,* shown on p. 65 (the earnest, bespectacled artist looks a bit like Rockwell might

OPPOSITE
Girl at the Mirror
1954

norman rockwell

have looked at that age) to *Girl at Mirror*, we see the artist's sympathetic understanding of what girls and young women had to do to gain approval, and what happened to them when they bucked the expectations. Clearly, Rockwell enjoyed the tomboys.

Rockwell was sensitive to the psychic pain of teenagers, and he was a master commentator on the agony and the ecstasy of dating and courtship. The mirror he held up to a still-innocent and cultural isolationist American generation of 1917 with his *Post* cover *Two Men Courting Girl's Favor* (p. 44) reflects a universal and visceral discomfort: The girl is torn between the suave man and the tentative young man who approaches her with a dance card. In fact, Rockwell may be at his best when it comes to the subject of women. Certainly his treatment of women as women shows how far he was able to stretch and how he appreciated (and did not resent) the ways women can and do take charge. He painted women from newlyweds to grandmothers, from professionals to blue-collar workers, and they're invariably the stable center, the ingenious fixer, the positive pole. Whether they are working at home or in the world, Rockwell is in touch with their interior lives. His interpretations run from stereotypes of what women indulge in (that would be gossip) to raucous celebrations of their power.

Home Sweet Home?

Rockwell clearly idealized middle-class family and home life. He saw

Home For Christmas
1967

home as *the* place, the heart of American lives. He also watched families evolve from an era of multi-generational, one-marriage expectations to an era on the brink of the Vietnam War. While he acknowledged his preference for harmonious family life, he documented the pressures that families felt and the upheavals that beset them through two World Wars. **His take was always upbeat and positive.** No point in spreading pain and suffering, gloom and doom. The closest he ever came to admitting to the existence of the Great Depression was *Hobo and Dog* (p. 56), the *Post* cover for January 12, 1929.

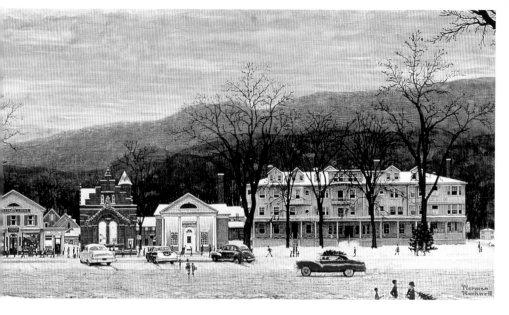

Pride in the Military

Norman Rockwell held the military in the highest regard. This was as true of World War I as it was of World War II. His patriotism found some of its purest and most idealized and heroic expression in portraits of soldiers, sailors, and marines. He was equally at ease in showing the ordinary draftee foot soldier and the field nurse in off-moments. What seemed to inspire him was the willingness of young people to make an unconditional sacrifice to defend freedom. By showing ordinary men and women slogging through their chores and relishing the

packages and letters from home, Rockwell acknowledged everyone's sacrifice and suffering, without painting blood and gore.

The Artist Arrives

What remains to be done is to honor Rockwell the artist, the man who, in an age when many artists painted for themselves and about themselves, stayed faithful to what he knew he did superbly well: paint for others and about others. This vocational decision meant that he had to resolve the conflict between what his patrons (magazine editors, publishing houses, institutions such as the Boy Scouts of America) offered him and finding the outer limits of his innate artistic vision and creativity. In a sense, he chose *We* over *I*, service over stardom. Paradoxically, he became a star in his lifetime, and because he was a great artist, his art is coming into a new and more refined focus.

So what do you think? Is he an artist or an illustrator? The decision is yours. But in the meantime, millions of grateful viewers say, "Thank you, Norman Rockwell."

Triple Self-Portrait
1960